COVID Vortex Anxiety Opera
Kitty Kaleidoscope Disco

"Only an artist, writer, and performer with the magnitude of talent, power, compassion, and vision such as Karen Finley could shape the fear, loss, grief, anxiety, and the inequities of the COVID pandemic and our world into song, elegy, verse, an opera, an epic poem. Only she could comfort while leading us in a collective cry for action, freedom, and justice, and offer a prescription for our survival through art."

—**PAMELA SNEED**, author of *Funeral Diva*

"Karen Finley doesn't just address the grief and the gloom of the COVID year. She guides us with wit and poetry through a kaleidoscope of recent traumas: the police murders that necessitated Black Lives Matter, the end of abortion rights, and the rage that still lingers from our last epidemic, AIDS. This is a natural for an artist who's made it her life's work to tell the awfullest truths and to give voice to the marginalized. This is how disco becomes opera."

—**CYNTHIA CARR**, author of *Candy Darling: Dreamer, Icon, Superstar*

"Karen Finley's *COVID Vortex Anxiety Opera Kitty Kaleidoscope Disco* is a visceral flashback to the landmark turmoil of our recent past. After expressing her fear and grief, Finley gathers the energy to argue for peaceable politics and meaning-making community. Ironically, the artist once declared 'indecent' by the NEA ultimately makes a plea for decency—for love and tolerance, human dignity, and the virtues of civil society."

—**SARAH THORNTON**, sociologist and author of *Tits Up: The Top Half of Women's Liberation*

"Karen Finley is like a profane Mother Goose for our contemporary world, weaving together verses and drawings to guide us in making sense of the cruelty of so many pandemics—not only viral, but political too. Like the best nursery rhymes and cautionary tales, she recounts scenes of life during COVID that are both extraordinary and mundane, and reassures us that, while many things rest on fate, how we respond is ultimately in our own hands. Some pieces read like seething battle cries as we face ongoing storm, while others are soothing lullabies offering a momentary respite of calm. Either way, in her oracular wisdom, Finley reminds us that the only way to survive is through community, creativity, and care."

 —**LIL MISS HOT MESS**, author of *If You're a Drag Queen*
 and You Know It

"Only a magician like Karen Finley could turn a nursery rhyme into an elegy, fast and furious and funny, shimmering glitter grief metastasizing loneliness into that collective scream dream. Here it is—mourning and mayhem, anxiety brain-drain shame game dancing with wisdom and whimsy, sashaying out of isolation and into a frenzied call for camaraderie. Karen Finley knows that masking the pain only makes it worse—here she lets it loose so we can truly live."

 —**MATTILDA BERNSTEIN SYCAMORE**, author of
 Touching the Art

COVID Vortex
Anxiety Opera
Kitty Kaleidoscope
Disco

Karen Finley

CITY LIGHTS BOOKS
SAN FRANCISCO

Library of Congress Cataloging-in-Publication Data

Names: Finley, Karen, author.
Title: COVID vortex anxiety opera kitty kaleidoscope disco / Karen Finley.
Other titles: COVID vortex anxiety opera kitty kaleidoscope disco
 (Compilation)
Description: San Francisco, CA : City Lights Books, 2025. |
Identifiers: LCCN 2024037665 (print) | LCCN 2024037666 (ebook) | ISBN
 9780872869356 (paperback) | ISBN 9780872869363 (epub)
Subjects: LCSH: COVID-19 Pandemic, 2020—Poetry. | LCGFT: Poetry.
Classification: LCC PS3556.I488 C68 2025 (print) | LCC PS3556.I488
 (ebook) | DDC 811/.54—dc23/eng/20240826
LC record available at https://lccn.loc.gov/2024037665
LC ebook record available at https://lccn.loc.gov/2024037666

City Lights Books are published at the City Lights Bookstore
261 Columbus Avenue, San Francisco, CA 94133
citylights.com

To the ever-evolving emotions
of grief, loss, love, and hope

CONTENTS

Venus Envy

Tell me,
Venus,
where are
you today?
Are you clouds,
slumbering as
velvet ovaries
Or as minds and hands
of bird feather compassion
Gifts of winter roses,
a sun glimmers on lace
The obscure, the arrogant,
forlorn ghost
Sentimentality crumbles like
uneaten toast.

Tell me, Venus, where are you today?
Are you in my eyes?
Staring into sky and space
Withering in sly disgrace.

Tell me,
Goddess,
where are you?
Where our body
is not *your* body
Autonomy, agency
will not be taken from us
Our bodies will
not be forced to procreate
Our bodies are not our prison.

Tell me, Love,
where is the love in hate?
Where is the optimism
in violence?

Tell me, Venus, where is the humanity in Uvalde?
Where is the love in the shooting of Breonna as she slept?
The killing of Black bodies out of hate?
Where is the love in war?
The pain trauma horror
The violence remains
Forcing a ten-year-old
to give birth.
Where does love assist
in ending violence
and brutality?
End white supremacy
End the patriarchy
Demand justice
Now.

Oh, Venus, dear heart
No more thoughts and prayers
Insist on justice in the name
of your sacred heart!
Provide and support
our empowerment
To transform hate
with all our creative,
imaginative strength
And change
oppressive
senseless
systems
forever.

Am I more
than my mask

Mask

You are more than your mask.
Am I more than my mask?
Tell me, am I more than my mask?
Am I more than my mask?
Can you see me for who I am?
Do you see the real me?
Can I still be vain with this N95?

What is the mask I show the world?
Which one do you want to see?
I hate this mask
hate this mask
this mask
Mask
Love the mask
Make friends with the mask
I make friends with my mask.
Be kind to the mask?
Be kind to me?
Be kind to the mask?
Oh, gentle mask.
Sweet, gentle, tender mask.

Take off your mask
I have to take off this mask
I must take off this mask
The stress, the pressure
I can't take it. I can't take it.
Sigh
What am I doing? What does it matter?
I need to stop
Get your hands away from your face!
I am double-masked and double latte-d.

Growl like a dog.
Get on all fours.
Let me be your COVID pet.
I want out, out of this con-ta-mi-*nation*
Growl Meow Moo Chirp Oink.

Control that mask of yours!
Control that mask of yours!
You are one crazy COVID fool!
Don't lose your cool with COVID
Do you prefer a Corona-virus Haiku?
Please, drop me in a tub of Purell
This dystopian cry for help
Can I long for the times when we swarmed into
clubs and glitter
Drinking Long Island Ice Teas, Hurricanes,
Hennessy and Coke
Wall Bangers, Margaritas with plenty of salt?
A Cosmos, a Sunrise
The tinker of ice against glass
in a gutter.

I'm so paranoid
On the subway,
escalator, plane, bus
Or alone in my own room
The clusterfuck of virus
Crammed with a microbe slurry
Creamed shit sitting next to you
Breathing in fetid coughs of dreams
and manic panic.
I double mask and close my eyes
I am able to see anyway
Jesus is here somewhere
We wait our turn in six-foot
circles of distance.

I love New York City as the *hotspot*
And now it's a Monkey Pox *hotspot* too
Even a little polio.

I love New York like Greta Garbo in *Camille*
I love New York like I love Joan Didion
I love New York like I love Michael J. Williams
I love New York like I loved David
I love New York like I love Lou Reed
I love New York like I love Ana Mendieta
I love New York like I love Louise Bourgeois
I love New York like I love Anthony Bourdain
I love New York like I love Marcus Leatherdale
I love New York like I love Harry Belafonte
I love New York like I love Stephen Sondheim
I love New York like I love Audre Lorde
I love New York like I love Susan Sontag
I love New York like I love John Lennon
I love New York like I love Kathy Acker
I love New York like I love Danitra Vance
I love New York like I love Andrea Dworkin
I love New York like I love Ron Vawter
I love New York like I love José Muñoz
I love New York like I love Greg Tate
I love New York like I love bell hooks
I love New York like I love André Talley
I love New York like I love ...

I love New York like I love you
from across the street across the river
across the bridge across the tunnel
I love New York like I love poetry, books, music,
art, fashion, and culture
I love New York like I love a bagel and cream cheese
I love New York like I love its thunder

It's 5 a.m. on Second Avenue
Finding the sweet spot
in this hot spot
It's dawn and sunset
It's darkness and sadness
It's callous and comfort
It's solace and relief
It's joy and loss
It's distant and near
It's obscure and very dear
It's nothing and everything
It's bada-bing bada-boom
The coffee street cart-art beckons
Warmth between our hands.

When do you introduce VORTEX DYSTOPIA to a child?

Stay Inside

Stay inside.

The Virus wants to get you.

The Virus is getting you.

The Virus has appeared.

Where is Virus? Virus is in the air.

Virus is here. Like God, Virus is everywhere

Virus is everything.

Virus is all the time.

Go to sleep, close your eyes, Virus,

Let me sing a lullaby

Quarantine is my safe word.

Hello, Virus, are you there?

Where is Virus hiding?

What surface do you lay
your heavy heart on?

Why is this happening?

Virus, Virus, where are you?

What have I done?

What is it? Do I deserve this isolation?

This anxiety, fear, and trepidation

Outside a never-ending alarm

Of sirens' screeching sounds

Constant high-alert emergency

Shock, troubled, insincere calm

Offer a trembling prayer

For those needing immediate care

Ask for gentle guidance please

Grace amidst uncertainty.

Don't come too close.

Keep your distance.

Don't gaslight me, Virus.
Virus, where are you?
Wear a shield over your breath.
Waiting for the air to clear.
The pulley is strewn with saliva flair
Waiting for a dramaturg
Walking up the stair
Living in a chandelier
A time machine crystal dare
I offer you flowers for all of your lip losses
of thoughts
and prayer tosses.

Do your symptoms remain?
Clusterfuck, headaches drain
Memory, loss, pain, and chill refrain.

Inspire and offer imagination
Offer vision, vista with a view?
If not, then shelter in place with sweaty grace
Armageddon awaits with heavy heart.
Climbing a December red rose canopy
To walk beneath Omicron bloom and thorn
Carve your name on a picnic table
With no relief from the COVID storm.

Are we some kind of apocalypse portico?
Let us instead move to the calypso
as the sweet-voiced calliope
or a lucky calico cat
and stand in an empty Zoom gazebo
memorizing lines for a virtual script
A toothache that just won't go away.

'Cause it is all my fault!
The life I have led.
There is nothing like a pandemic to pour a drink to
Steady measure. Just use a bigger glass.
It is my—your—fault.
It's all your fault!

Don't bring up the manatee now.
I said, don't bring up the baby seal now.
I said, don't bring up my lost relatives now.
Don't COVID shame me
or I am the reason
Blame me, please!
Blame me!
Who can I blame?
We are not all in this together.
We are *not* all in *this* together.

No, I do not want to have a Zoom family reunion.
No, I do not want to have a Zoom wedding.
No, I do not want a Zoom memorial.
No, I don't want to organize a Zoom funeral for my partner.
No, I don't want to have a Zoom reunion get-together.
Or a Zoom karaoke snack shack.
No, I prefer my misery with a blur screen, please.
Thank you very much.

No, I am not okay.

It is not going to get me.
It has gotten me.
It has gotten you.
Stronger than COVID?
Weaker than COVID?
Stop it with the COVID comparisons!
STOP IT.

Stay with me
Be my Tinder provider
I don't want to lose you
We've already been direct messaging
I love you even on this virtual screen
Come with me.
Let's have a COVID fling
Let's go viral
Become a #hashtag
#covidfling #pandemicflirtfuck #covidpickmeup
Bring me back the simple life
When #notgivingafuck was a worthy option.

God is watching over me.
Oh God!
Pray in your mask.
I will strangle COVID
Be gentle with COVID
Take the violence out of COVID
I don't feel like talking about it
I wish it went away
Microchip, entropy, embodied.
I wasn't able to say goodbye and then you died.

All extra everything
The circle of neglect regret fret
If only I knew this before
Now you tell me, you despicable viral friend.

It is just too controversial in COVID
parenting circles:
When *do you* introduce
vortex dystopia to a toddler?

Let her cry it out.
Let us cry together.
Let me have the dignity of my own tears.
The immensity of the loss and not being able to say goodbye.

Don't talk to me about your depression medication just now
Not until after Rachel Maddow.
It is all too horrifying, when you use the term
crazy love wilderness
And offer a peace sign and dried mango
I don't need your suggestions to show COVID love
Measure your COVID love
With the appearance of red cardinals in the snow
Are you my warm COVID friend today?

Let me be a cloistered COVID cunt
My COVID cunt is semi-quarantined
Something about shimmer
Glimmer
Remains
Red cardinals cluster
Against the blizzard storm
Two fly off
One remains.

make friends with your MASK

Please Put On Your Mask

*F*ake smile under the mask

Excuse me. Yes, excuse me. I am smiling under my mask,
showing openness and good will, my fellow American,
and you are not wearing a mask.
Could you please put on your mask?

We are all crammed in this stopped elevator and I would
appreciate it very much if you would wear your mask. Hello,
could you, would you, please wear the mask, so it covers
your nose?

Would you please be able to put on your mask?
I know that you can take your mask off when you eat
but you had a three-hour lunch and you have not had
a bite in an hour so could you please put on your mask?

Would you please be able to put on your mask?
It says that you are to wear a mask and you are not
wearing a mask. You are on the phone without a mask.
You can talk on the phone
with the mask.

The mask is real
Please put on the mask
I said, Please, please
Put on the mask.
Put on the mask.
I said, can you put on your mask?
The mask is your friend.
Really, it is a very friendly mask. Trust me.
It hasn't done anything to you.
I'm saying it nicely.
It doesn't have anything to do with you.
It has everything to do with me.
It has everything to do with you.
I'm with you, here with me.
You are breathing on me.
You are a fucking asshole.
The virus is real.
You will not get COVID by breathing in while wearing a mask.
It doesn't work that way.
Sometimes the mask is a mask.
Wear the damn mask.
The mask is not your mother.

I said, wear the mask.
I said, wear the damn mask.
Wear the damn mask
The damn mask
Damn mask
Mask.

Cover that face.
I know that I show aggressiveness with my asking.
I am working on my COVID tone.
I will improve my COVID-manner work-out
I promise.

Hey!
(smiling with a twinkle)
Can you put on the mask?
Let me try hand gestures
Mask please *(point hand to mouth)*
Pointing to that rude nude nozzle
PUT ON THE MASK YOU SELFISH BASTARD!

Try different ways
PUT ON THE F**KING MASK
PUT ON THE EFFING MASK
PUT ON THE FUCKING MASK
#fuckingmask
What do you mean, you won't put it on?
You have had enough.
It doesn't work, it isn't real.
This is all so fake.
I will show you fake.
You want fake?
Take the mask away
Take the mask away
Mask away
Them away
Away
Away
Away, away.

· EVERYONE CHEERED
like an open wound

Covid Vortex

There is a twister in town
 called COVID Vortex View
A wild mixture lunch hunch
 A lonely, outcast, quarantine bunch who meet
Shivering in some frozen, curbside, shanty-café
 On a makeshift COVID take-out Tavern Street
 With a broken heat lamp greet
 Trying to ignore the city pee-smell perfume
 All in for a cocktail brunch whiskey egg
 Some pandemic plague punch
 Irish paper cup, coffee to go,
goddamn Bloody Mary sippy cup whatever
 A zombie bottle snuggles
My broken everything bagel,
 King Lear schmear.

Let's share this traffic stop bistro
 A desperate welcome break
 from Zoom gloom, please.
 Settle in this rough and crumble shack
 Get the witch's broom to clear
 Only a few dozen rats chew
Scatter unaffected in midair
 Whew!

 A whirlwind quarantine Zoom sizzle flirt
 Variants and altered dimensions dirt
 Daily COVID alert hurt
 de Blasio and Cuomo compete
 Words from Fauci can't be beat
And that doctor lady with the scarves

 A kind of Corona avoid ride glide
 COVID fashion statement avoid ride
See you in a Zoom breakout
 room for Pride!

Sometimes this vortex is a shapeshifter
　　　Lasts for days or for hours, months or years
　　　　　In a fraction of magical realism
　　　　　　　You do not know where you are
　　　　　　　　What day it is?
　　　What day you are on?
　　What planet you are on?
　　　When you changed your clothes
　　　　　Before or after *Tiger King*?
How long you have been wearing ... anything ... or nothing!
　　　I guess it is time to make friends with the Paper Tiger.

　　　Sometimes you stare into space.
　　　　　　You are on the internet reading something
Or you just baked bread or did a project with chia seeds
　　Two days passed and the SCOBY is nowhere to be found.

　　　　　　And suddenly you miss humanity
　　　　　and recall your long lost love teenage years
　　a quiet whimper without shedding tears
The peace sign disposable mask fogs glasses
　　　　　And then you hear some more bad news
　　　　So you keep this all to yourself and store this emotion
　　　　　　in some locked, secret place
　　　　far away, yet tethered nearby
　　　　　　Even with a smile.

You can't remember the future or repeat what it was
Working in some time-warp where your eyes cross on cue
Or just get lost in a vortex COVID tunnel stew
You can't remember what you did
or who you are or who you have become
or who you ever were
to make you so clouded
And so you wait another day
and then you are tired from waiting
and then you order in or go outdoors or plan on something.
There is the glazed look
everything takes forever and every task is infinity
Depression isn't *completely* to blame
Your hair and beard and roots grow out
like you have been dead for six weeks.
It is a dimensional curse of
cortex vortex display
And it is getting worse.

You try to distract or look
 at the sky
 Take a walk
 Get out of town
 but the vortex is still there
 the freak-out.
A week has passed and then a month
 and now it is another
 year and another year
 or two or three.
Doesn't matter anyway
 What you planned to do
 Some do not make it back and
some habits are better than others
 You either have lost
 everything or found nothing
 Except the twisted discomfort
 of this dystopian galaxy
 How can you help
 provide some PPE?

Heartbroken shock sorrow
 misplaced fright
 The phone rings
 The texts
 No, no, oh no
 They didn't recover
 They didn't make it.
 Were they alone?
 Did they suffer?
 You open the window it is 7pm
 You cry a cheer.
Everyone cheers like an open wound
 For the medical field,
 the essential workers, first responders.
 Just to make sound
 Send a meal. Try to help.
 Try not to get sick
 But you do.

Animal Videos

I need an animal video
Let's read aloud together these animal video titles:

possum and bird
cats and dogs
giraffes and baby and momma
piggy and kitty
squirrel and peacock
butterfly and honeysuckle
peacock and pony
zebra sweet sounds
fox and furry
angel fish and unicorn
lion and cobra
lamb and snake
mermaid and chinchilla
ox and hugs
galaxy and mercury

moon and crab
troll and frog prince
virgin and apothecary
angels and harmony
eagle and grace
centaur and forgiveness
archer and tornado
wind and rain
sun and moon
tears and fears
elephants and moonbeams
butterflies and ladybugs
chimeras and turtles
angel fish and rhinoceros
escaped owls and coyotes in town squares

Let me look at this nature
and all her connections
Please let me wonder
to reduce self harm
A moment of tranquility and charm
A giggle and squeak in baby talk
While no one is listening
All is better
Is better
Better
Coo coo

But no, it isn't, not quite
Please let me see the
angelfish press its wing against
A seahorse

All better
All all all

Oh, here it comes,
anxiety and despair

Let me see two zebras kiss a skunk
All better
All better
is is is
Better

Let us call out our pet names
Say sweet animal pet names here:

I love you, Bow Wow
I love you, Bell
I love you, Harriet
I love you, Bonnie
I love you, Black Cat
I love you, Muffin
I love you, sweet animals, who are so dear

Please include your pet names here.

Covid vortex
Anxiety Opera
Kitty Kaleidoscope
Disco

Let me dance
Oh, let us dance
The pandemic is here
Embrace your sorrow glitter
Your sparkle and spangle shimmer
Open your heart with mirrored circles
Hairspray required, shiny pants that flick
Looking for dick.

Welcome, Ice Blue Chanteuse Chartreuse
Maybe a Mai Tai, a Stinger on ice
Kahlúa and Cream Monster
Champagne Cordial cocktail
In the corner with wetness dripping
Smoke and glassy eyes
Let's pretend to forget this disease
Be carefree.

Music booming tunes looming
Forget the worry
Stumble and unzip your dagger
Squeeze beneath your intimacy swagger
To recall secret longing
with strangers
Desire within dark cherry jubilation
Of excess and numbness foreplay.

Teach me all the parts of you shedding off leatherette
While speaking to Ethyl Eichelberger, Haoui, and John Sex
That I wish to recover and restore like a belly button ring or
Hot pink, rainbow, panty-line thing
Try a camel mound curtsy poem with Cookie
It's one thousand-a-day death toll by now.

Let the mourning begin on the dance floor
My Zoom disco
My dance floor territory across the anguish border
Be one with my body
Breathing in and out together.

Oh sweet despair, unrequited love snare
Hold me tight, never let me go
To gather and glance together
The heavy breathing of strangers
and nightlife friends.

Let me be your partner
Let me be your problem
Palms grasp
Sizzle encounter
And then you realize it's only yourself on the dance floor
A drum beat and Sylvester collapses
The death fall.

When looking for a bump snappers poppers crash or crush
But all of this only makes me sadder
Rub my tummy with some CBD gummy oil
Take the sound even slower and lower
An empty forlorn yearning.

Keep looking in that smoke and mirror
With the kaleidoscope repeat episode of
Danitra Vance on SNL
Her talent surreal
To remember, honor, all the New York dreamers
never ends but befriends.
Yet the disco is common and familiar now
Someone puked and made in their pants
Back to lockdown
Back to emergency
Back to death.

I'm running down Broadway
The Towers are falling
The Towers are falling
The Towers are falling
They all fell down.

Everyone
said the air was safe
Too much to grieve or escape
Don't look back.
I thought I saw Andy, Liza, Whitney, Prince
somewhere
But that was on Hulu.

Party like it is 2020
Party like it is 2001
Party like it is 1968
Party like it is 1987
Party like is it 1975
Party like it is 1918
Party like it is 1945
Party like it is 1929
Party like it is then
Party like it is now
Party like it is tomorrow
In the party there is hope
In the dance there is life
In the movement there is joy, rebellion
In our gathering there is connection, resistance
You can have both feelings at once
Let the sorrow move with the joy
Let the sadness move with the smile
In our love we move our sorrow together.

Just crank up the music
Or let it hum quietly.

Damn, Sister, what a fool
It's just another day in old New York
I swear I'm not dancing on your graves
But preparing for the garden
As you taught me
When you brought me to
The dance floor
Moving it forward
Feeling the love
Being love.

Cooking

Let me make for you and eat for you
A hummingbird cake
A delicate, moist, luscious, creamy, dripping, oozing
pppp puss puff puss pussypastry pussy
pudding pussytry pastry
Or lemon mousse or fingerlings
The cakes and sticky buns are here
Let me lick my lips
Frosting here on my ships
A banana-pear upside down wake
There is caramel salties and twinkle biscuit bear flaws
Chocolate ganache sliding on clementine aches
Apple Betty and raspberry hazelnut buckles
Celebration carousel chuckles
with water lily marshmallow glaze
The pandemic is steady, ready, out of control
But I am

whipping, creaming, baking, blending, stirring, stripping, sautéing, skinning, skimming, icing, frosting, kneading, melting, breaking, grilling, stewing, brewing, whisking, beating, pounding, icing, smoothing, cutting, chopping, slicing, dicing, cracking, folding, rolling, pressing, making.

Give me amaranth flour liberty or give me breath!
Buckwheat pancakes, rye, and carob
Angel food with a swirl of something
Peppermint essence, butterscotch scone
Lavender meltaways
The temperature is rising
Nurses despair
Patients refuse to get vaccinated.
Some refuse to wear their mask
Believing in a hoax
Eventually kills them all alone.

It is toasted almond meringue crust, isn't it?
The COVID is merciless
The dead are counting
The bodies gather in bags
The lime parfait could have been sweeter
There is mocha cream pop-up tiramisu
The lungs can't breathe
The lungs collapse
Intubate
Make the pudding from scratch
Knead the bread
Let it rise
The deaths keep coming
Don't be surprised
Bodies in our parks in our streets
Before our eyes
The virus stays to compete
The elderly leave us behind
No goodbyes.

Time for homemade kombucha
with the mother
Or every type of Mediterranean cuisine
And all the different types of basil
And rose-infused teas
As you cling to life with some tube and gasp
A rhubarb strawberry cake and gingered tears

A shabby-chic rustic iron crock
Holding the obliging batter
In a secure, hospitable place
No space, no bed.
The cancer returned
A warm stove as friend, as confidant
To open and close as mother's womb
There is no answer or treatment
Found dead two weeks later.

A fire, a heat
A taste, to treat
Nourish
Against defeat
The unburied
And unclaimed forgotten
Dying, bleeding, cough won't go away
Gasping in some hallway
Triggers memories
of the gray halls of St. Vincent's Hospital.
The uncared, untouched, unfed
AIDS patients
with a meal tray left outside of a room
lack of care and humanity.
The Catholic Church closed St. Vincent's
for money
For real estate development cash
To pay off Catholic Church sex abuse scandals.

To think how St. Vincent's Hospital
could have provided
Needed beds during another virus.

Where is our faith and charity?
Let all the cakes burn and go to hell!

Tropical Splash

Wet Ones

ANTIBACTERIAL
HAND WIPES
KILLS 99.99% of Germs
Hypoallergic
WET LOCK SEAL
KEEPS WIPES MOIST
LIFT HERE

20
wipes

Washing Hands

Turns out none of us really knew how to wash our hands.
We were doing it all wrong.
It took a pandemic to show us the way.
So happy that *finally* in 2020
I was taught how to wash *properly*
My thumb and palms, the *right* way.

Just waiting for the right lather
Settle on lavender soapy and Dial sterilizer proxy
Constant washing, chapped, membrane mitts
Antiseptic tropical-rum-vanilla-aloe-vera balm
Still needs more bleach

It is all so dirty, so filthy, filthy
Contaminated with the foul, impure, grimy
Living on hard surfaces, hoarding the perfect wipes
Coconut germ-killing splash spray shield
These paws roughened coarse to emphasize
All-in for microbe surveillance reconnaissance
The desperate virtuous fight laments
A safeguard for ultimate protection.

I have never spent so much time at the faucet
Counting to 100, staring ahead as instructed
Looking into my hands
Everything touched and felt
Let me look at your palm
and give you a reading.
The life and heart line
The ring of Jupiter
The mound of Venus
Nails bitten near the sliver moon.

As a child standing on a stool
Brushing teeth before bed
All the Band-Aids and boo-boos
The moments to disclose privacy
The toilette ritual, the reading material
Flushing and disgrace
The odor of floating turd
That won't go away.

Behind the medicine cabinet mirror
A reliquary of migraines, cuts, and bruises
First menstruation and the last
The miscarriage and aborted
The dribble and drab
Wash these hands with scrubbing fierceness
When hands were forced to perform sex acts at gunpoint
With angered determination
Washing my discharge and membrane
Or gentle coaxing to get away.

Holding baby's first cry
Singing a nursery rhyme to go wee-wee
Or head in the bowl and face on the tile
Please, don't take this virus out on me
My hands at prayer asking for mercy
As they held your last breath
Don't slap infection despair
These hands have held, carried, caressed,
Swept and wept,
Clapped for joy.

Let me restore, inspire, recover, heal
Please, oh sweet, tender hands
That have held and hold
Laughed, loved and restored
Touch
Intimate
Caress
Feel
Be.

make my exhaustion
A BIRD

Everything Is Exhausting

Everything is so exhausting
Yes, everything is so exhausting
Everyone feels this way.

Should I get off from this couch?
Shall I turn my head?
Should I wipe my ass?
Can I look away?
May I stay?
Do I need to talk?
Can I just forget?
Can it all go away?
Do you even care?
I need to get out of here
Where do I go?
Can I just pretend this isn't happening?

Yes, everything is so exhausting
Are you sick yet? Am I sick yet?
I am feeling so sick. Oh, who is sick?
Can't I just get sick and get it over with?
This is all so sick
I feel so sick
I am in quarantine.

Food left at the door
At risk and scary
Don't get infected from the pizza box
How many are leaving us?

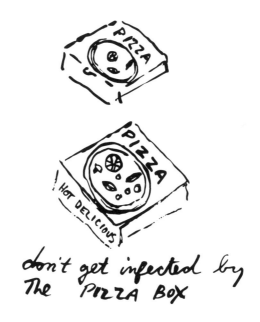

The gloomy
and the miserable
The emptiness surrounds us
I want to see you
It has been so long
Can I pick up this fork
or eat with my hands
I want to see you
but I just can't.

I am on the train the subway
 Walking the streets
 Looking for a moon
 Try to be in a hurry
 The hustle bustle
 Your breath in my face
 The taste of your memory
Your last meal I can evaporate
 Too many are going, all too soon, all too fast.

 The fatigue is here
 The fatigue is real
 Fatigue, my friend
 You have stayed too long
It is now time for you
 to find your way on your own
The exhaustion is really another name for sorrow
 Exhaustion is another name for sorrow
 I thought in disbelief you can't be gone
I wish I could have seen you
 One more time.

 I will try my best today
 Even in the smallest ways
 Let me make you smile
Even under this mask
 That weighs with heavy lifting.

Let me push through this despair
And open the door
To see past this feeling
To see past sorrow
With hope, faith, and smile
Where endurance can move towards future
To see this sunset, this dawn, this sky
As potential, as possibility
To make a difference
But to witness nature
With whatever way we can
Take action
Make it a love journey
Make my exhaustion a bird
Wings spread soaring
Anew.

MAKE MY EXHAUSTION
A BIRD

OH, grief Hold me close

Grief

Oh, Grief
Here we go again.
Oh, Loss
I am your constant companion
I was a child, now a teen
I was unborn and now a toddler
I was sick and now gone
I was healthy and now forgotten
I am gone and miss you
Growing old, growing up
Or any of life's unexpected milestones
Where have these past years gone?
The world explodes reality
An alternative take out universe song.

Oh, Grief
Hold me close
You hold on to this heart
I can't get over it although
I am so *over it*.

You hold on to this heart

Hello, Grief
Welcome to our time together
The mutual isolation
Joining in this
Many-year merry-go-round
Riding a vertigo-painted butterfly
Swirling kaleidoscope views
Lost or sad clown
A dizziness abounds
Hoping to reach the shadows of loved ones
Sweet angels, guide me to sacred ground.

Grief, have you processed?
I am so sorry to bring it up.
Sudden losses, fear, and haunted beauty
The slow progression of loved ones too far away
The agony not to mourn collectively
A hollow shrill, a brokenness
The shattered seclusion of abandoned memories
Soul and Psyche
Do you really exist?

Grief, I never really knew you
As well as you knew me.
I always thought we could get back together
I always thought we could say I love you
But Loss came between us.

Hello, Loss
So many have left us
So many goodbyes not said
Trying to remember the good times
and not intubation
I always thought I could have, should have, would have
Don't get tangled in all these Wordle webs.

The vortex holds on
My very own internal anxiety opera
I'm selfish that way
Waiting in a very lousy way
As I swipe and sanitize down the groceries
with a bottle of vodka
Standing six feet away
As you masturbate at safe distance
It's a vision of streaming glee
Mesmerized for a moment
Where Amazon Prime
Becomes a terrorist activity
Yet you don't want them to leave.

the Vortex
holds on

Oh, Grief, come back!
Where are you?
At least my heart feels as the
numbness retreats
I didn't turn my back on you
I don't accept this heavy loss
As we pause for numbers of
How many dead
Parked in cabanas as cold truck graves.

Where is our daily update from the governor?
Or being told to drink bleach in May?
Where the day occurs under the covers
Nights spent on some terrestrial, cinematic, telethon cloud
Oh, I have looked for grief in all the wrong places
Overcome by love, calling on love

Love never paid the rent
Love never made it free
Love never made it safe
Love with budget spent.

Help me, Humanity!
Where is this going?
What is this world coming to?
Dimensions physical or spiritual
What crimes have the police done now?
Who have they killed?
What state, what person of color is ambushed
What drag queen is terrorized.

My white cis body named Karen
I am the body of a cruel mistress
It is not what this world is coming to
but where whiteness
 has always been.

Dimensions of desperation
Careless selfish expression
Families repair
Restore relief
Sanctuary
Repeat return
Repeat return
Oh, just shut up
Stop telling me what you just watched on Netflix
or podcast
or your problems with your fancy getaway
Or that you have no one to clean your house
Please.

Eulogy

So many have left us
The loss and the sorrow
Not having a place, a space to mourn.
Here is our eulogy for the lost and left.
For the death that occurred and we learned after the fact
For the family member, the partner, the friend and neighbor,
the stranger
The artist, colleague, and the coworker
The celebrity fantasy who we called by their first name.

Dear Ones, I keep your names close.
Some left their homes and lived away
COVID economies, losing housing or health.
Sometimes living with friends and family, different situations
Sometimes we never got the full story.
This loss, the hole in our heart
Either by old habits returning, addiction, panic, and isolation
The absence, the ghost of what we have become
When we found out they passed
we were not able to be there to guide, to protect or hold them.

We have our personal losses
The people in our lives
There is no closure.
There are other absences
of routines, jobs, relationships, neighborhoods, and dreams.

We mourn for so many who gave their lives
as medical providers.
We mourn those killed,
Murdered by brutality—
police violence—
Black bodies.
We mourn the countless mass shootings
and how our society is business as usual.
We mourn the killings and attacks of those targeted
of Asian descent and association and the racism that exists.
We mourn the impact of COVID
and health inequities on so many.
We acknowledge the occupation
of Indigenous lands that we are on.

We mourn the loss and impact on mental health in our society.
We mourn the experiencing of houselessness.
We mourn those suffering from long-haul COVID.
We mourn our children, who have experienced the isolation
and the impact on education and social skills.
We mourn the loss of body, autonomy,
and agency with transphobia.
We mourn the removal and terror of not having healthcare
and abortion access.
We mourn and condemn all homophobia.
We mourn the attacks, discrimination, and legislation
against drag queens and all LGBTIQ+ people.

To the many people who have been traumatized,
maimed or killed and affected by war
We honor their memory and pray for justice to be served.
The forgotten, the isolated, the hungry, the forlorn.
Let us bring caring in our spirit and our actions.
We mourn climate change and those lives lost and injured.
The floods, fires, blizzards, heat, cold, air, droughts.
We mourn the loss and harm to animal and nature species.
We mourn the loss of habitat.

We mourn the loss of time, spirit,
opportunities, and possibilities.
We hold and extend sympathies to our neighbors
and humans who are devastated by the continued loss and grief.
Tender hearts hold this feeling of love close.

Let us heal
Let us restore
Let us forgive
Let us love.

transform

Butterfly Transform

This mask reveals so much hatred
Forgive me please
I can't love the hate away.
There is too much hate in this world
My heart is not yet full
I escape into a selfish desire to turn the table
I so want to kiss
To kiss this hate away
To hold this hate away
To look this hate away
To love this hate away
Oh mercy, not even with paisley naïveté
Can't bear
Can't stand.

The hate
Yet within there is a passion, a light
To cheer for love
Turn this hate to love
This sorrow to joy, action
With every child's heart
Every emerging hope.

There is no vaccine for hate
Or a morning-after pill.

It is dangerous to compare
Yet the sadness of loss is here
So many gone lingers
Trying to submerge, suffering surfaces
Grief embodied
Stay steady
As illness, virus still surrounds us or memory
But also remember the resilience, the courage and humanity
Memories don't forsake and take us.

You have your stories of pain, grief, and loss
Here we are now.
I honor your stories and memories
Too many feelings to sort
Contrition, sorrow beckons like a turtleneck
And hang my head back
With no way to escape
Drink it straight with one gulp
Lipstick stains my glass
And I wish on your mouth.
Can I fuck this grief away?
Can I eat this pain away?
Can I mask this loss away
Can I cry this grief away?
Can I read this sorrow away?
Can I make friends with this grief?
Oh loss, tell me your secrets, your loves,
your desires, your dreams.

We've seen some crazy shit out there
Some crazy ass shit
Sacred and profane
The humanity genocide
Acting crazy, bursting at the seams
Dropping off and out
Flipping the bird
It's a real shit show
High alert treacherous bloody
Racists.

We've seen some crazy shit out there
Meltdowns, outbreaks, surges, explosions, takedowns
Insurrections
Flare-ups, gusts, frenzies of anger
Sudden eruptions of losing control
Acting crazy—just losing it, mean, violent
Just losing your shit—cargo, ammo
Breaking at the seams
White people getting all mad 'cause their
brand of toilet paper is out
White people getting all crazy
Because they have to wear a mask on a plane
White people all crazy because they lost an election
Or that people protest against guns
White men so violent crazy they just blow up humanity
to smithereens.

There are so many catastrophic things that occur
Where do we begin or end?

Doors that didn't close
Windows that won't open
Ceilings that can't be reached.
Can we save our humanity?
Can we protect ourselves?
Isn't there another way out?
Can't this violence end?
Don't take this trauma for granted
Hallways, schools, groceries, houses of worship
Movies, subways, airports, malls, parks
Cars, home, and streets.

Don't give up, the spirit whispers
Can we have peace in our purpose?
How can we save this planet from ourselves?
How alarming the situation has become.

Can creativity transform this hate?
Can our spirit move us for social justice?
Can our imagination see other possibilities?
May we inspire a new future?
Let's insist that restoration and reparation are possible.

There is ingenuity and sparkle in your
Dance magic ritual
There is birth and renewal
Listen to the illuminated drag queen story hour.
Have a vision revolution as artists take to the streets
It's an art revolution
Make art not hate
Be public with your art
Don't take soul for granted
Our bodies are ours
Leave space for love
Little love grows to big love.

So I leave you here for you to
keep your heart strong
Courage with love
Be generous with our love, art, and humanity.

Let us believe in each other
Offer support
To be heard, to have choice.
There have been too many not believed
It is about belief, being believed
Trust and support
To show up.

My body is not yours
Remember, witness
If only Anita Hill was believed
If only if only

I believe you
You do not have to justify, validate
Give the evidence, put your hands up
Prove, pull your panties down, have the photo proof
The cash, the receipt, the down payment, the degree
The résumé.
I believe your experience, your life
Your decision, your body
What happened to you.

When you stopped speaking up
For you know you wouldn't be believed
You weren't expected to be talented
To amount to anything
You were here for other's pleasures, desires, and needs
But today, let us believe, support, encourage, inspire
Acknowledge, compliment.
Say Hello
Say, It's good to see you.
So glad to see you.
Even if you have never seen them before.
And that is how it starts
Like the butterfly
And that is how it continues.

Find your secret garden
Let me be a garden
Be a garden
All the different seasons, flowers, and views of nature
Thank you for coming to my garden, for coming to play.

And when you close this book
Look up. Look out. Look in.
It is an examined life that is meaningful and gives purpose.
It is gathering in public that gives fellowship.
It is the New York hotspot, our heart hotspot that holds our

dreams and hopes.

Because:

Maybe my life will be better if I can dream of a magic garden.

It will.

Maybe my life will be better if I see some theater.

It will.

Maybe my life will be better if I start a festival.

It will.

Maybe my life will be better if I become a friend.

It will.

Maybe my life will be better if I make some art.

It will.

Maybe my life will be better if I write a poem.
It will.
Maybe my life will be better if I get up and dance.
It will.
Maybe my life will be better if I play some music.
It will.
Maybe my life will be better if I sing my heart out.
It will.
Maybe my life will be better if we make a performance
together. It will.
Maybe my life will be better if I share my art with you.
It is.

ACKNOWLEDGMENTS

Thank you, to my friends, family, audiences, and colleagues for your support.

I am deeply appreciative to City Lights for making this book possible, and for the opportunity to work with this esteemed publishing house again. I am grateful to so many for their work on this volume: my editor Amy Scholder; Elaine Katzenberger, Publisher; Stacey Lewis, VP Director of Publicity, Marketing, and Sales; Jasmine Ellswyrth, book and cover designer; and to the rest of the City Lights staff. Thank you to friend and artist Astrith Deyrup, for inspiring this book cover.

I would like to thank producers Ron Lasko and Chip Duckett of Spin Cycle, and the Laurie Beechman Theatre, for their unwavering support of live performance in New York City. Special thanks for the production design by Violet Overn and tech by Jean-Pierre Perreaux, who worked on the show that was the source material for this book.

I am indebted to Uli Baer and the NYU Center of the Humanities, where I was a Fellow. And a big thank you to Dean Allyson Green and the Tisch Faculty Grant for Creative Research, which supported the development of the performance. Thank you to my chair Pato Hebert, my department, faculty, staff, and students in Art and Public Policy, Tisch at NYU.